SARA BERMAN'S CLOSET

SARA BERMAN'S CLOSET

Maira Kalman
Alex Kalman

HARPER DESIGN
An Imprint of HarperCollins Publishers

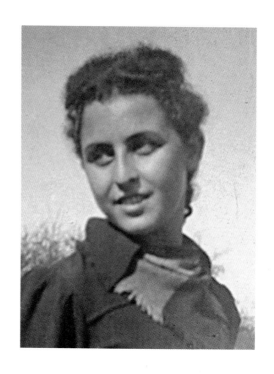

to SaRa

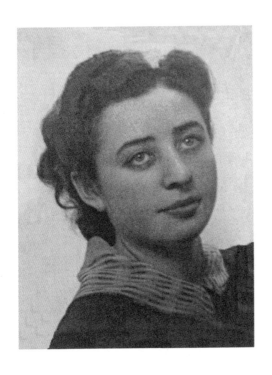

and Shoshana

In the little village
of Lenin in Belarus,
there lived a LARGE and
Reasonably Happy Family.

They Lived in a collection
of shacks next to the
Muddy River Sluch.

Yes, there were Pogroms.
Yes, there was deprivation.
But Life was not all bad.

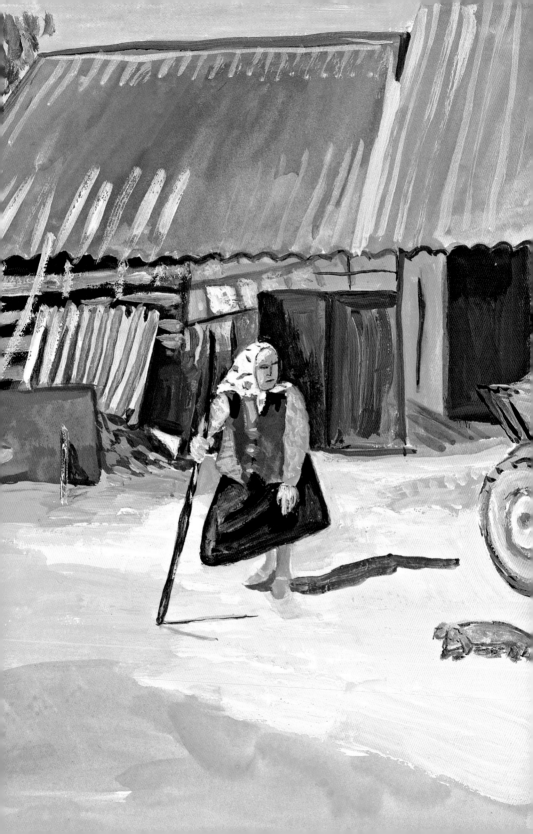

There was a blind goose-herder.

There were
Wild Blueberry Forests
where the children
Ran Wild.

And a
grandfather with
a six-foot-long beard who NEVER spoke.

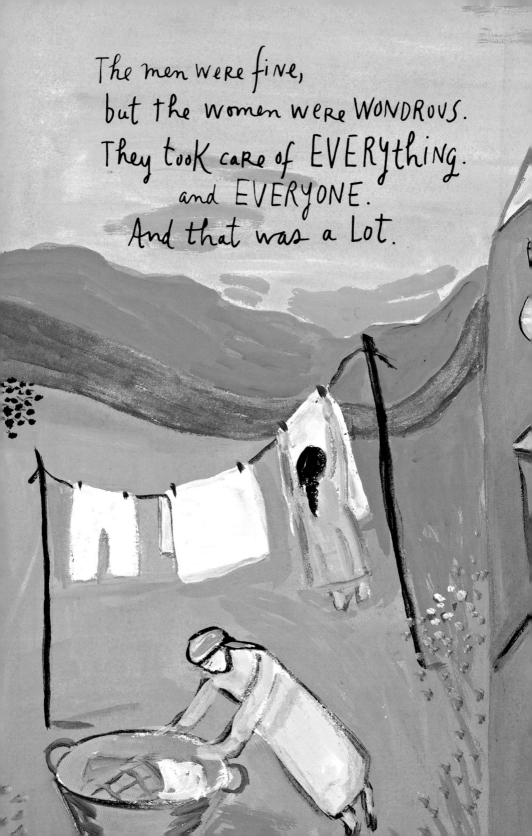

The men were fine,
but the women were WONDROUS.
They took care of EVERYTHING.
and EVERYONE.
And that was a Lot.

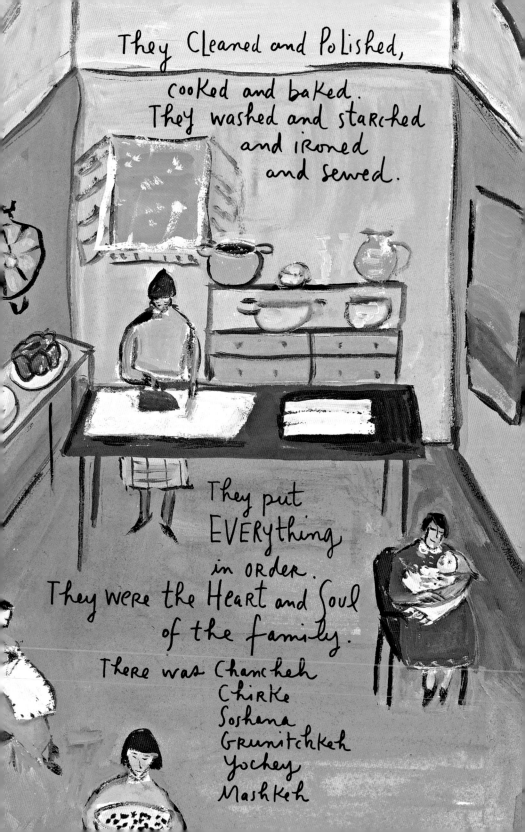

They Cleaned and Polished,
cooked and baked.
They washed and starched
and ironed
and sewed.

They put
EVERYthing
in order.
They were the Heart and Soul
of the family.
There was Chancheh
Chirke
Soshana
Grunitchkeh
Yochey
Mashkeh

And Sara,
who helped with all the chores
and also loved to Read.

Sara and her older sister
Shoshana devoured books.
Tolstoy, Dostoevsky, and
Chekhov were their friends.

They ate cake. They sang and
they danced. For them, life in
the village was a dream.

Many things happened
in this little village.

One afternoon, a traveling
photographer arrived.

All the children had Recently
had thir Heads shaved,
for fear of Lice.

But Shoshana Ran off and
cut her hair herself.

Her bangs were crooked,
but she was proud.

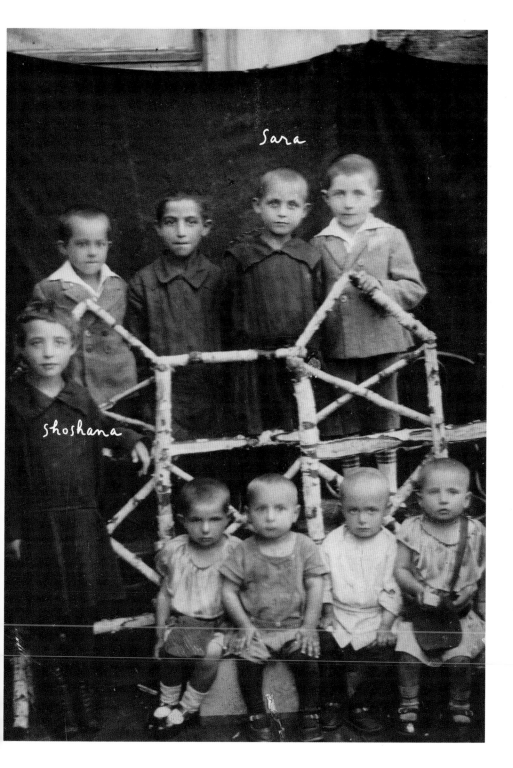

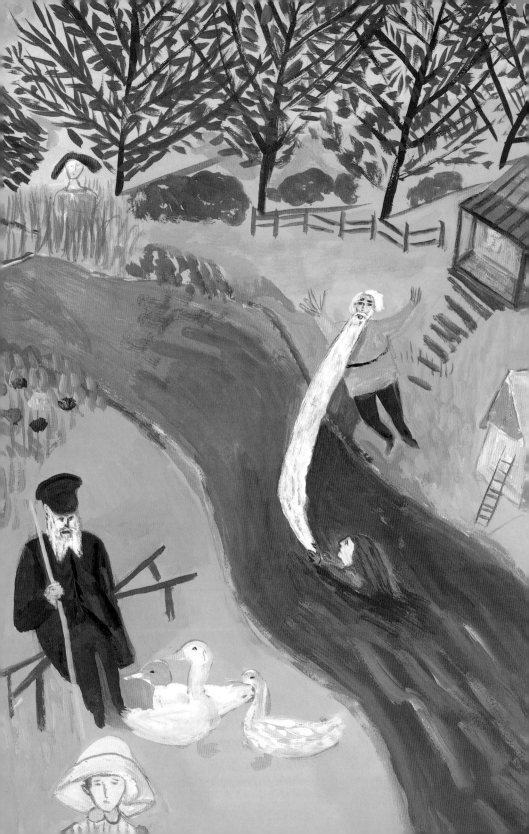

A FEW years later,
Sara FELL into the
muddy River SLUCH
and almost drowned.

But her grandfather
THREW his beard
into the water.

Sara grabbed onto it,
and he pulled her
safely to SHORE.

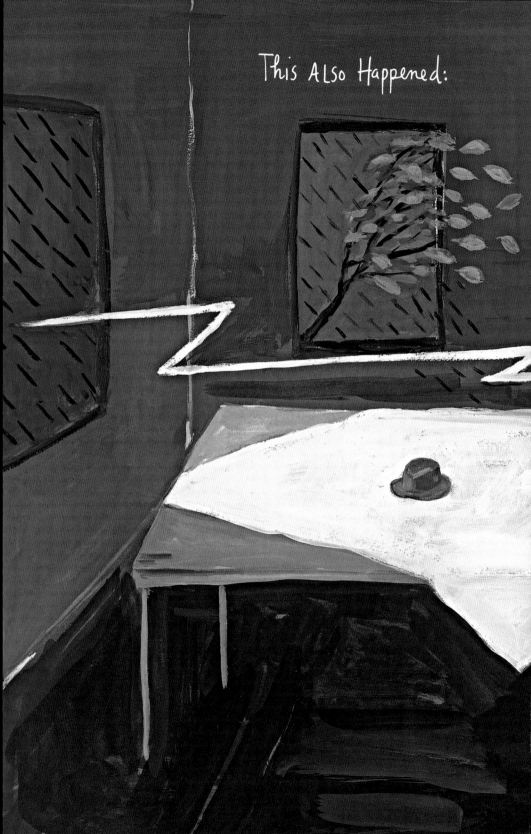

One clear day, SARA'S COUSIN was sitting in his SHACK, Reading a BOOK and drinking a GLASS of TEA. SUDDENLY the sky darkened. Rain began to FALL. Then a BOLT of LIGHTNING SHOT through the Window and KILLED HIM.

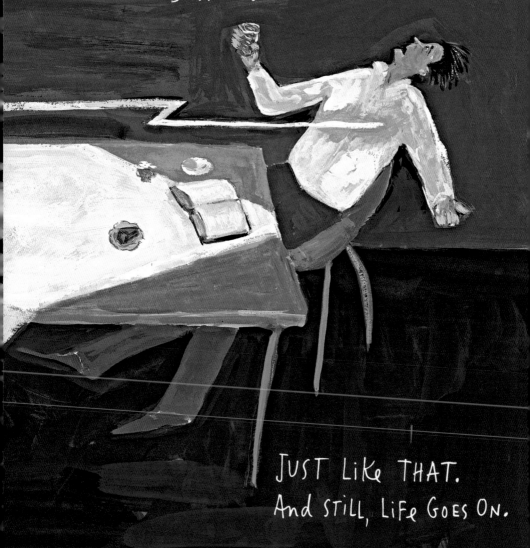

JUST Like THAT.
And STILL, LiFe Goes On.

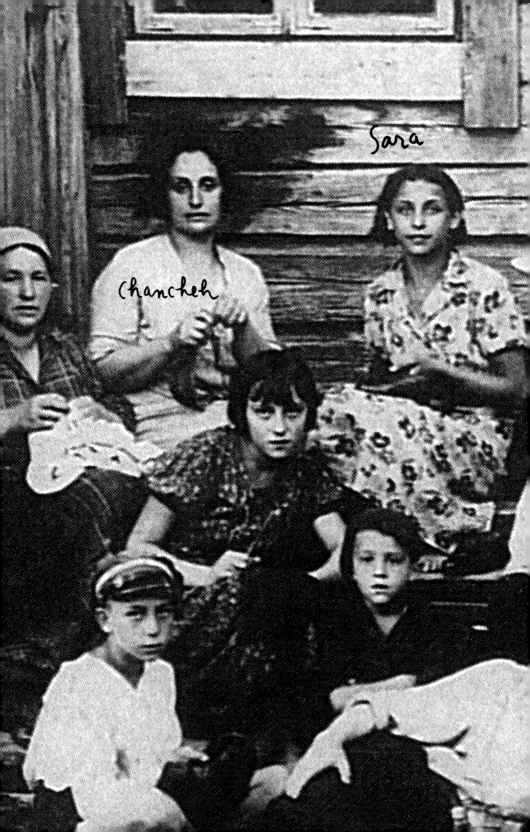

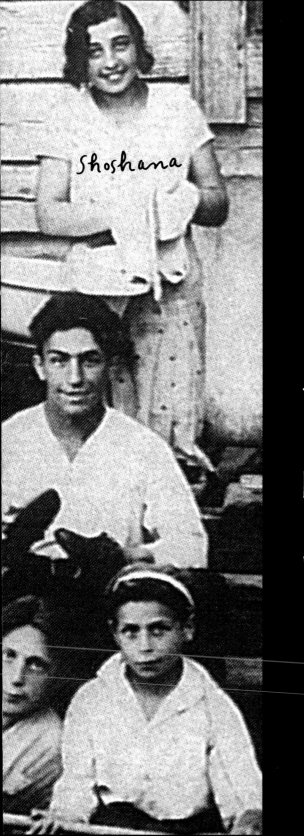

Shoshana

More days passed, full of activity. Everyone knew that being BUSY was a GOOD part of LIFE, otherwise you certainly could GO CRAZY.

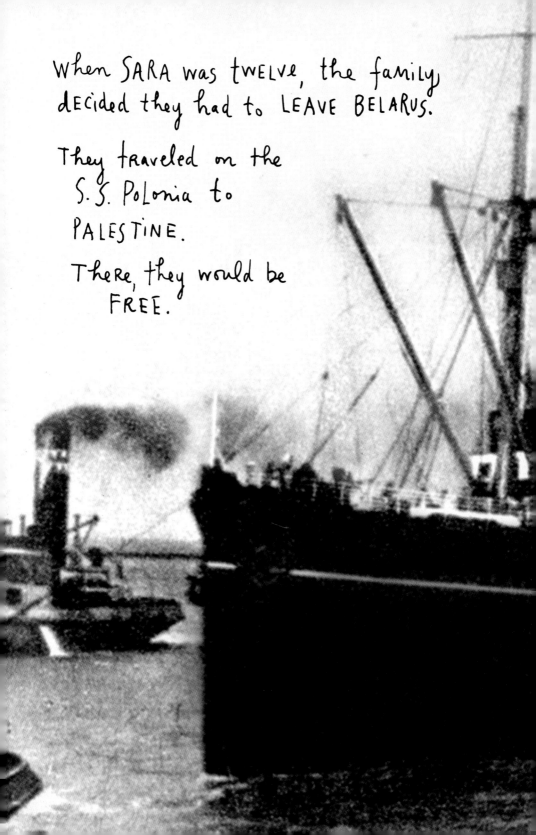

When SARA was tWELVE, the family
deCided they had to LEAVE BELARUS.

They traveled on the
S. S. PoLonia to
PALESTINE.

There, they would be
FREE.

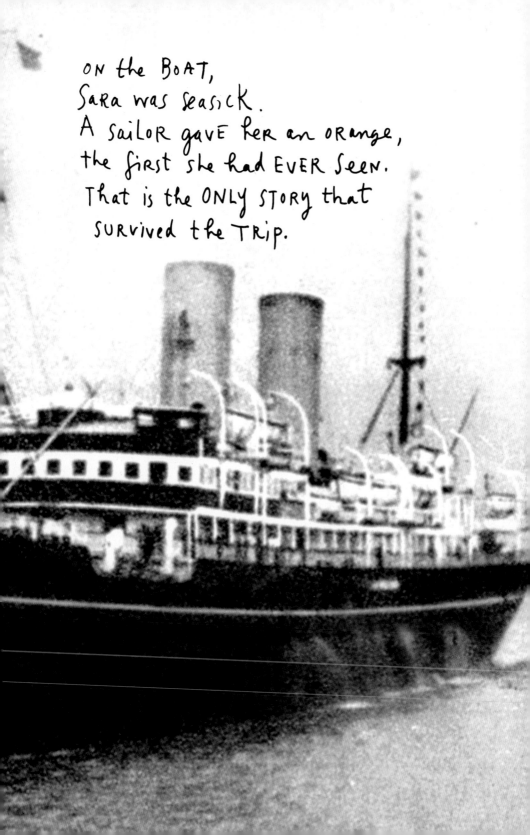

ON the BOAT,
Sara was seasick.
A sailor gave her an orange,
the first she had EVER seen.
That is the ONLY STORY that
survived the TRip.

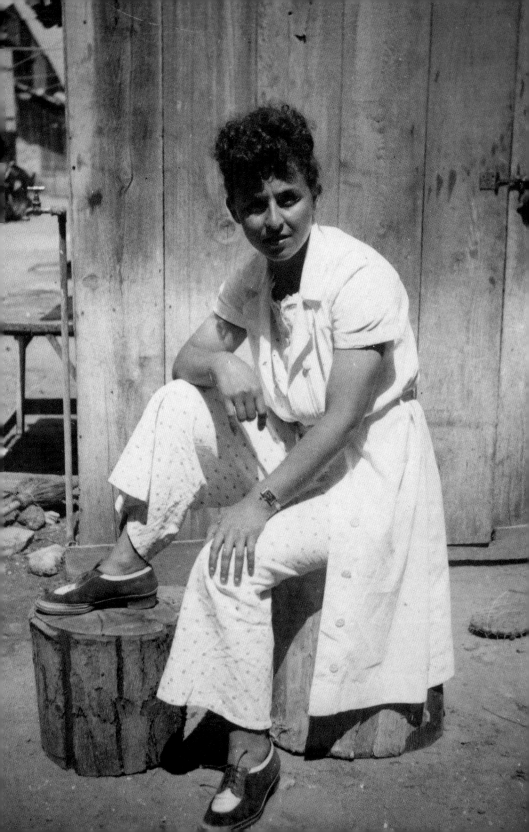

In Palestine, they lived in a SHACK near the BEACH. They tried to make it a slightly FANCY SHACK.

Sand covered EVERYTHING. But SARA still managed to look Elegant. Sara's mother sewed outfits copied from European fashion magazines.

The women were always washing, ironing, and baking. Friday was the day for super-cleaning and super-baking.

The Middle Eastern sun bleached the laundry a Blinding WHITE. Fanatically starched and pressed linens were folded precisely. The clothes were so heavily starched, they could get up and WALK AWAY.

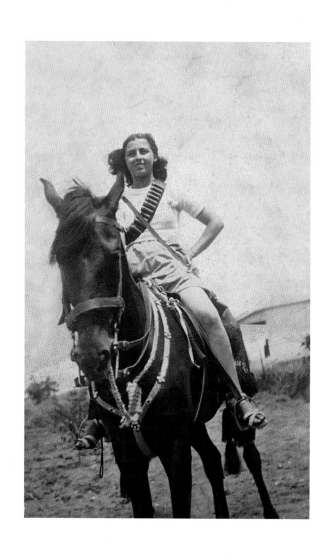

SARa WAS COURAGEOUS.

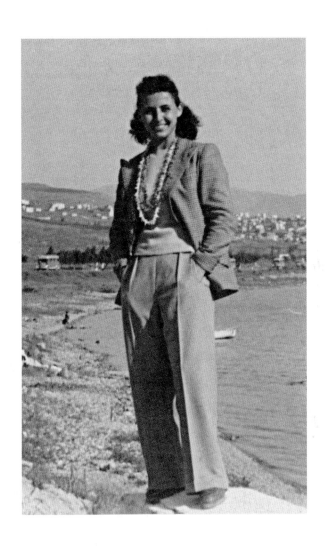

And Ravishing.
And FUNNY.

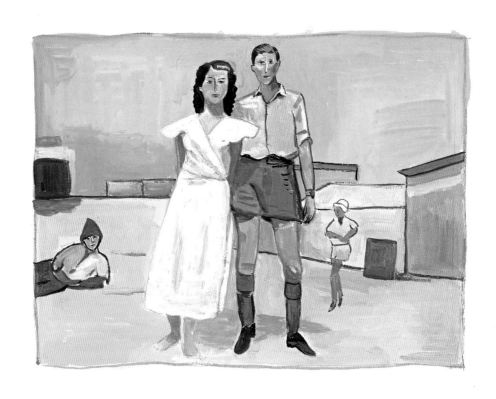

EVERyone
WAS MADLY
in LOVE
with SARA.

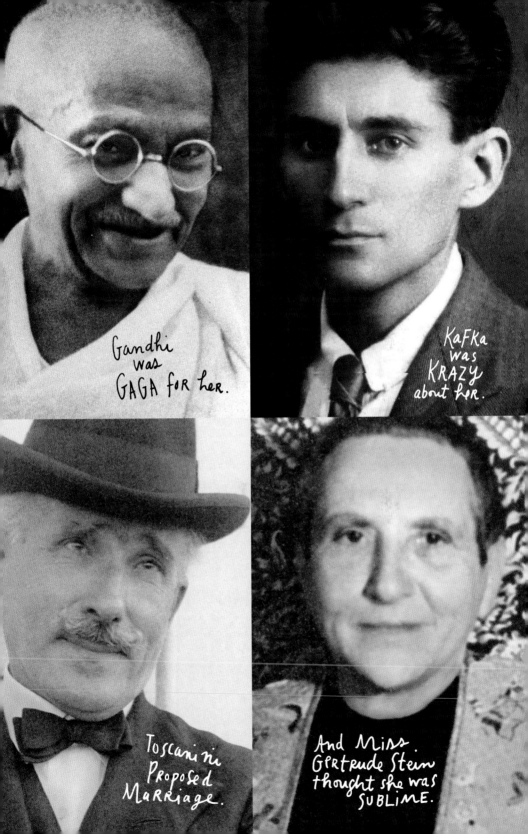

Gandhi was GAGA for her.

KaFka was KRAZY about her.

Toscanini PROPOSED MaRRiage.

And Miss. GeRtrude Stein thought she was SUBLIME.

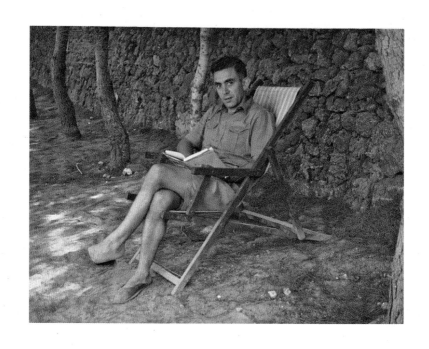

SARA met PESACH.
He had deRRing-do.
He was dappeR.

They danced the TANgo
undeR the FlutteRing
awnings of seaside CAFÉS.

He puRsued heR with
ARDOR. And she said YES.

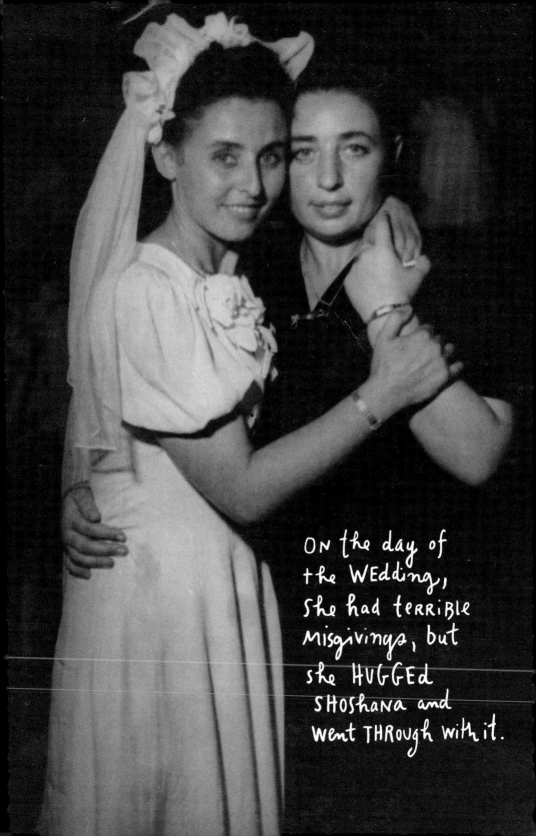

ON the day of the WEdding, she had terRIBle Misgivings, but she HUGGED SHOshana and Went THRough with it.

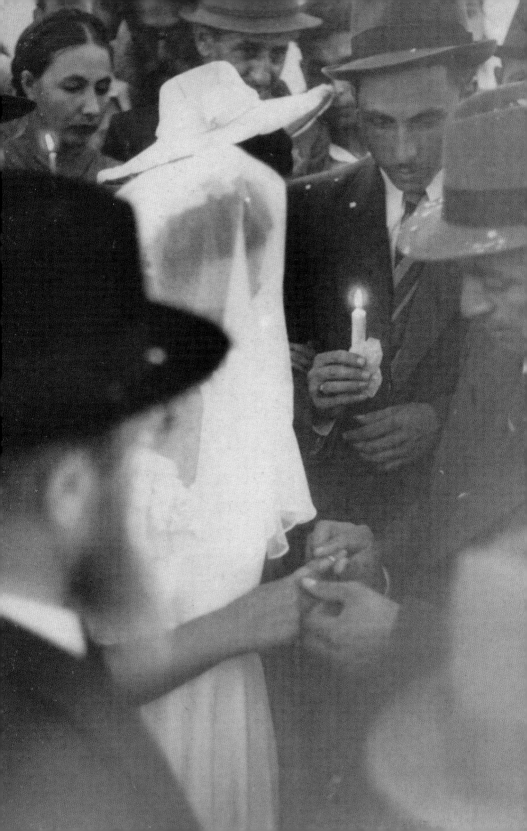

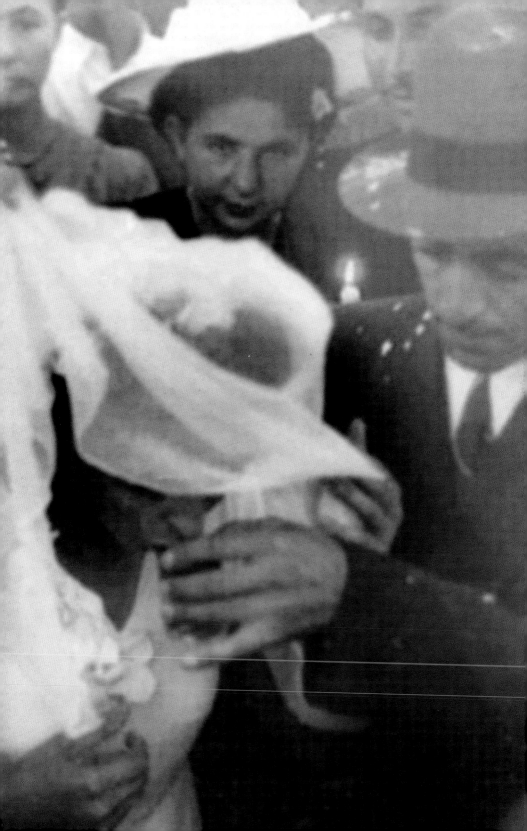

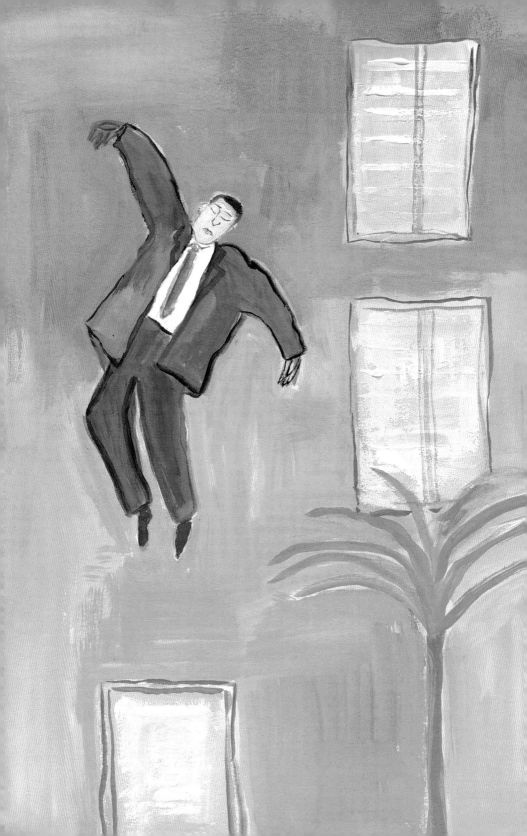

In Tel Aviv, many
things happened.

One afternoon, Sara
and Pesach were locked
out of their apartment.

Pesach decided to climb down
from the neighbor's terrace
on the third floor to their
terrace on the second.

Without warning, Pesach
slipped and fell all the
way to the ground, but
did not get hurt.

He was wearing a
GRAY SUIT.

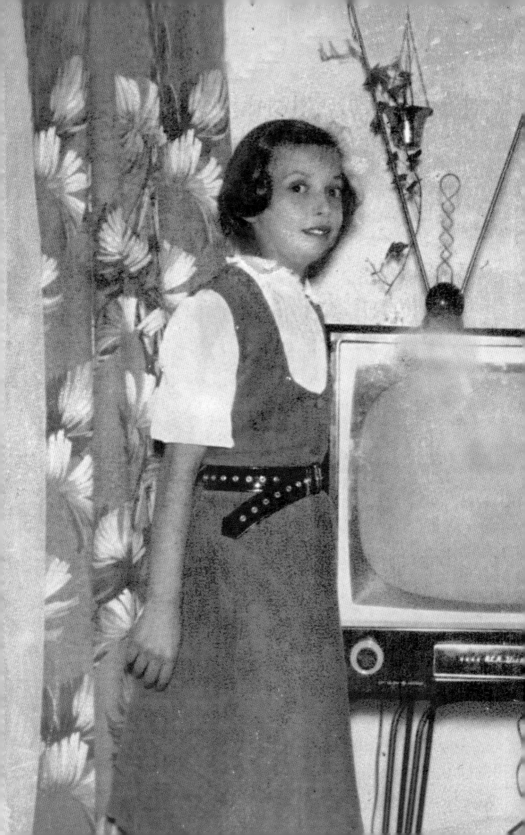

Sara and Pesach had two daughters,
Kika and Maira. The family moved
to New York City, where they saw their
first television set and drank their
first Coca-Cola. They read VOGUE and LIFE.
They ate EGG ROLLS and SPARERIBS every
Sunday night at BO SUN Restaurant.

They went to
Concerts.
Museums.
OPERAS
and
Musicals.
It was a
CULTURED
LIFE.

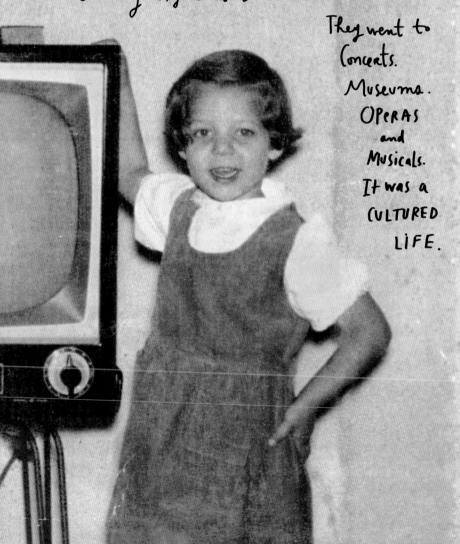

THE Years Went by,
as they tend to do.

When Kika and MaiRa
went to college,

SaRa and Pesach moved
back to Tel Aviv.

As time passed, the cracks
that had been there since
the beginning of their relationship
could no longer be ignored.

Their marriage fell apart.

At the age of sixty,
after thirty-eight years
with Pesach, Sara understood
that she had to leave him.

One night she left
with just one suitcase,
saying good-bye to
Everything she owned.

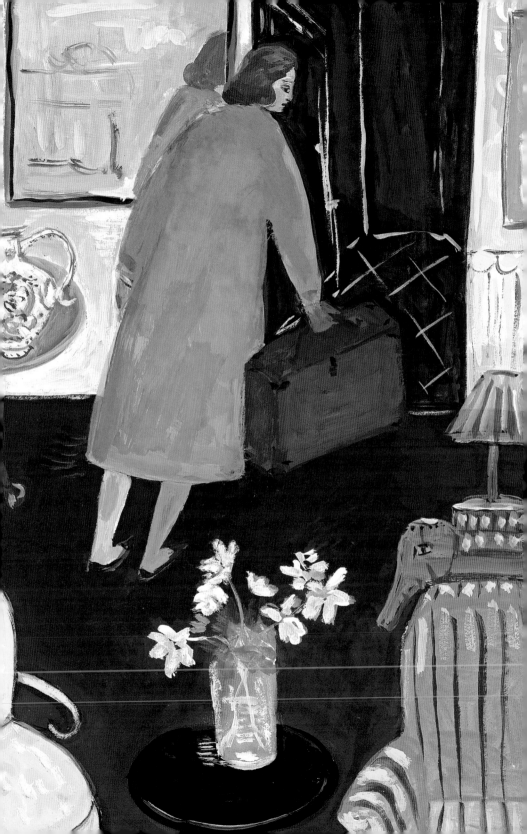

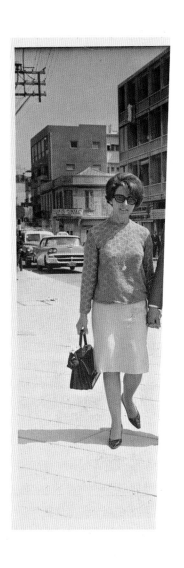
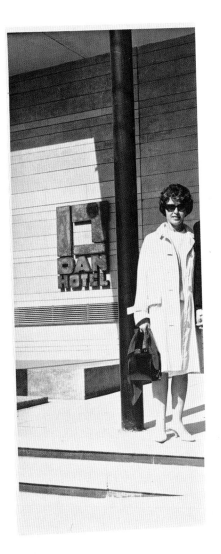

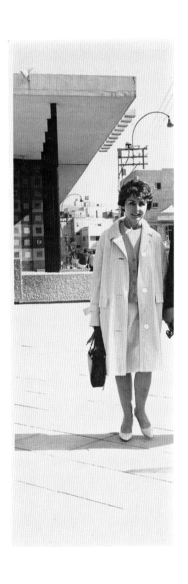
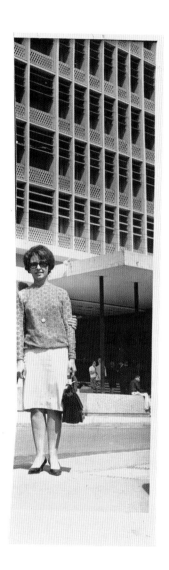

She cut Pesach out of her life.

IT

WAS

A

LIBERATION.

SARa joined her daughters
in New York City,
a place she Loved.

She Found a small studio
apartment at 2 Horatio Street,
in Greenwich Village.

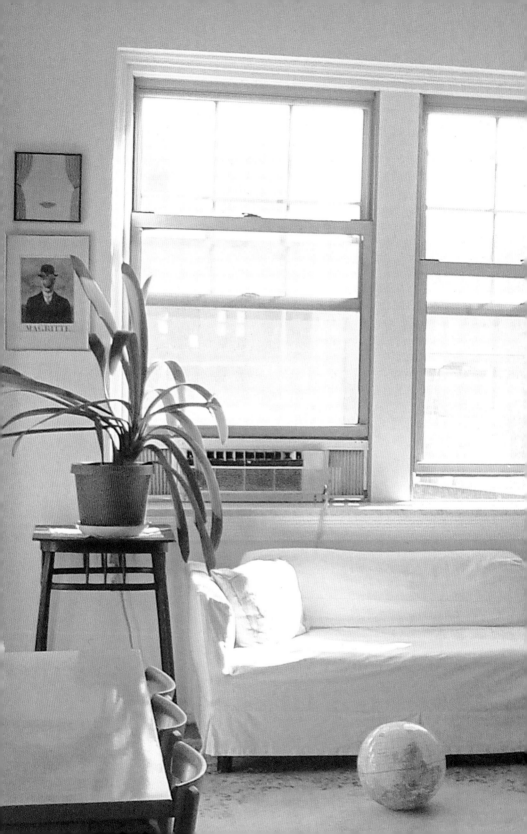

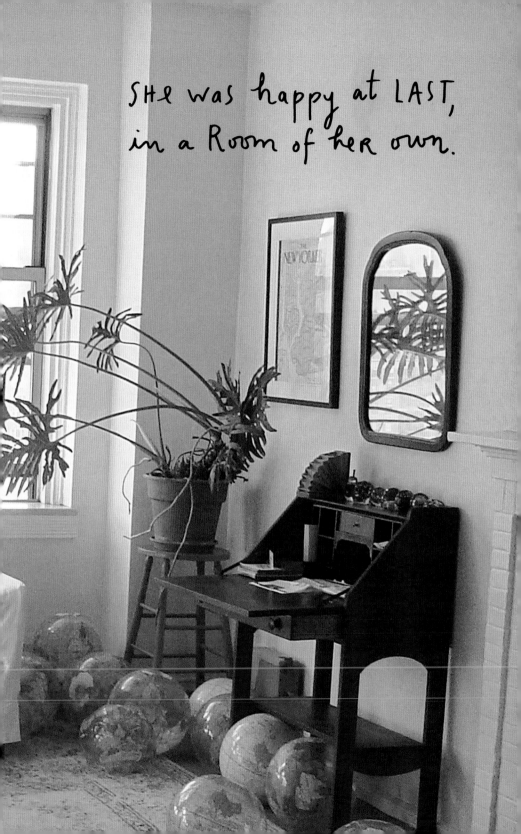

SHe was happy at LAST, in a Room of her own.

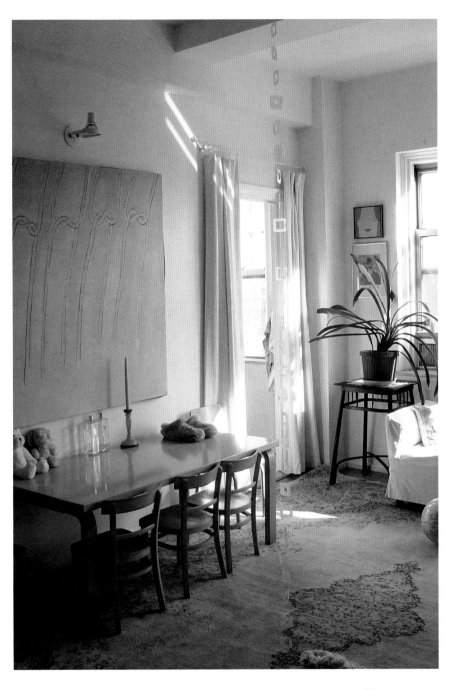

Things had changed for the Better,

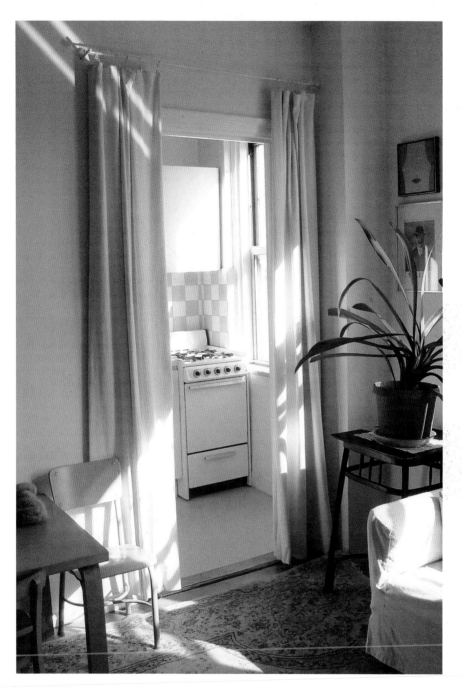

which is NOT always the CASE.
BUT sometimes is.

What was her new life like?
She cooked schnitzel and Blintzes for
the family in her tiny Kitchen.

She was
WILD
about
Fred Astaire
and watched
all his Movies.

She Read
AutoBiographies.

She sat at the Kitchen taBLE and ate HeRRiNg. She watched JEOPARDY! every night at 7:00 P.M.

She went to the Museum of Modern Art on Wednesdays and ate PIZZA in the cafeteria.

She edited out useless
distractions. She cherished
the small moments,
which are the sweetest.

Every action was done
with care. Every day
was filled with
precise and brilliant
actions.

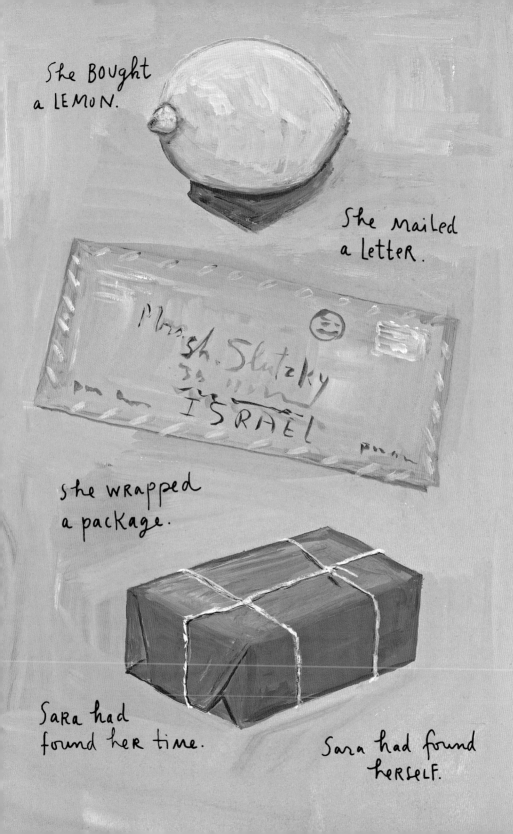

She BOUGHT
a LEMON.

She mailed
a Letter.

She wrapped
a package.

Sara had
found her time.

Sara had found
HERSELF.

One Friday morning in a BURST of PeRSonal ExpRession, she decided to wear ONLy white.

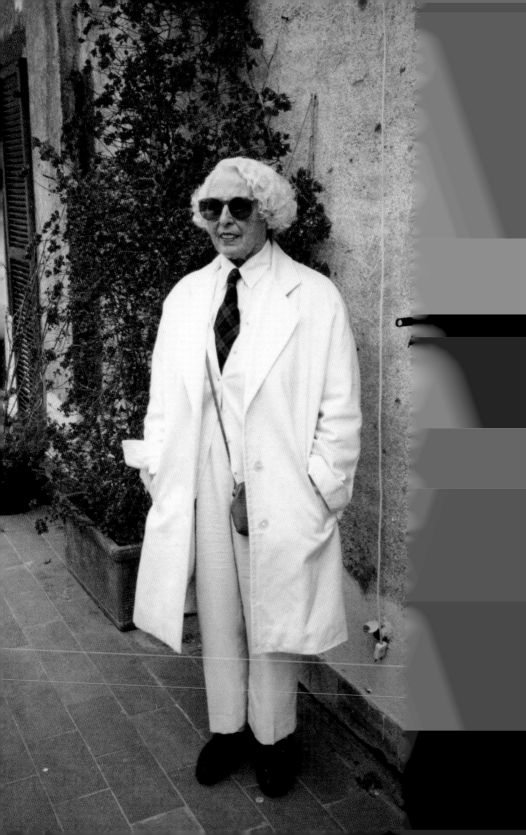

She starched, ironed, folded, and stacked everything, with loving care and precision.

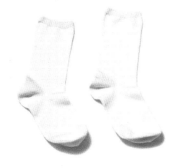

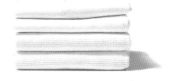

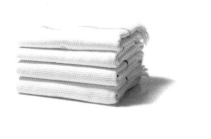

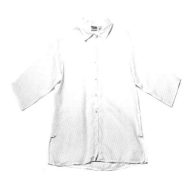

All of it was grand.
And her closet was the
grandest of all.

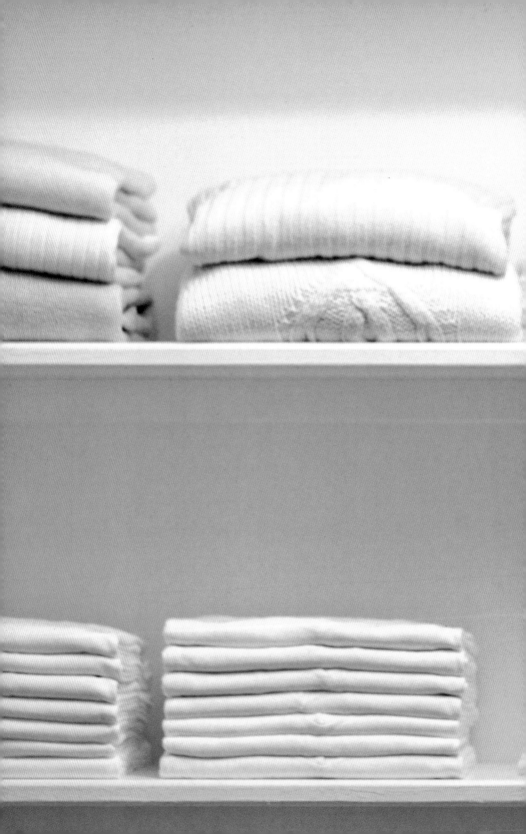

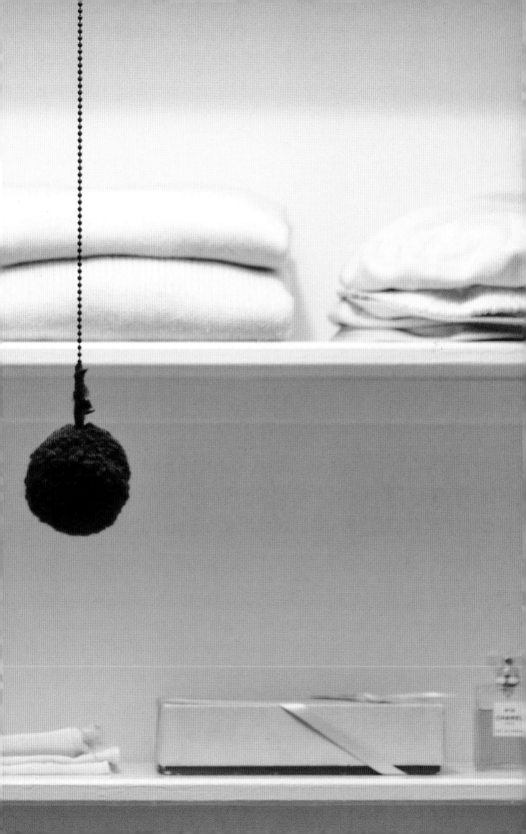

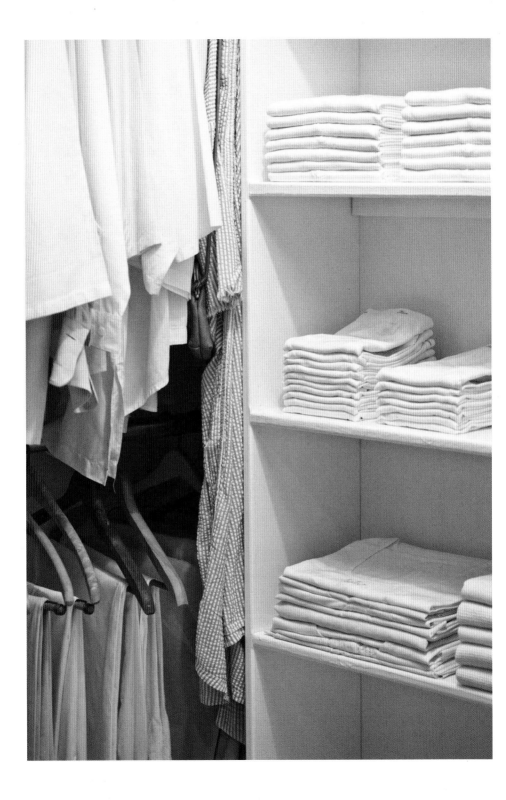

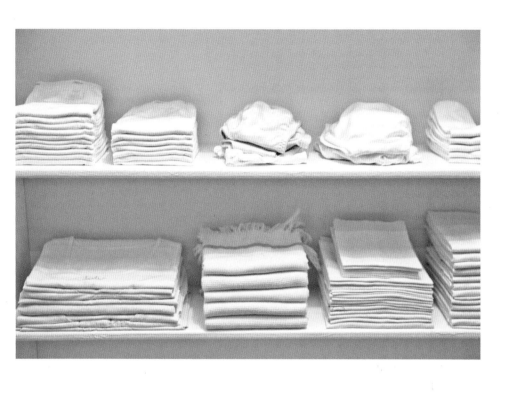

There was a place for everything.

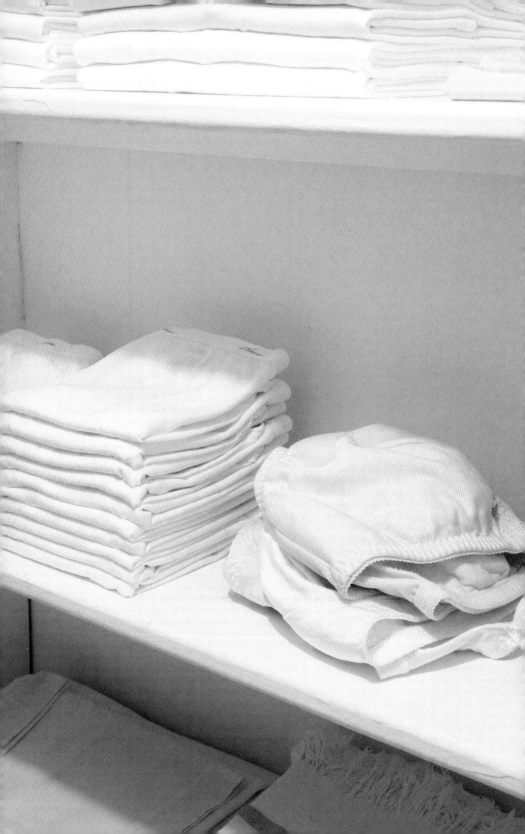

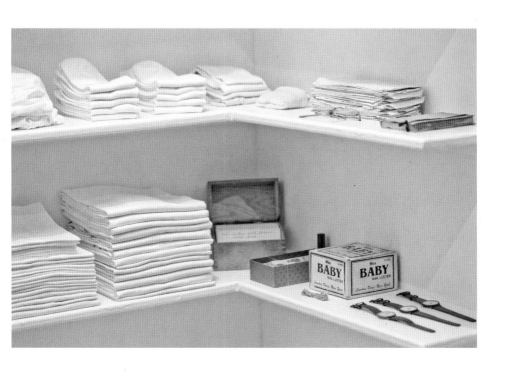

And everything was in its place.
She knew what she had.

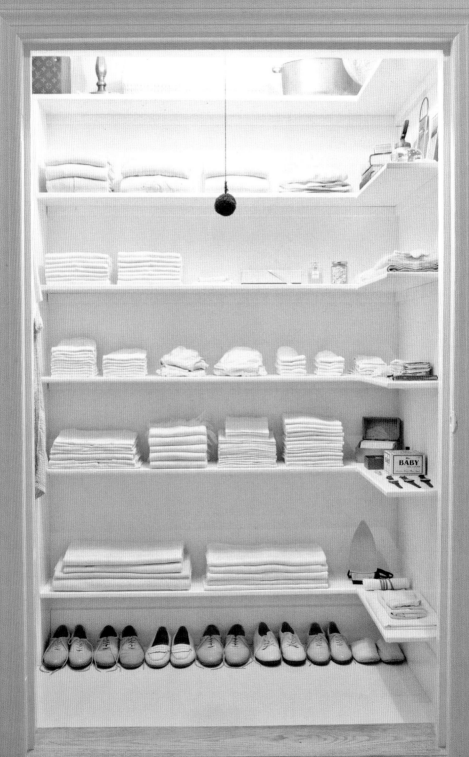

What did she have?

UNDERGARMENTS.

Seven BRas. Twelve T-shirts.
Thirteen pairs of socks.
All pressed and neatly folded.

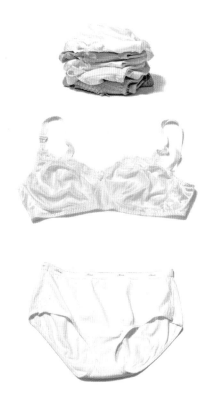

(Yes, she ironed her underpants.)

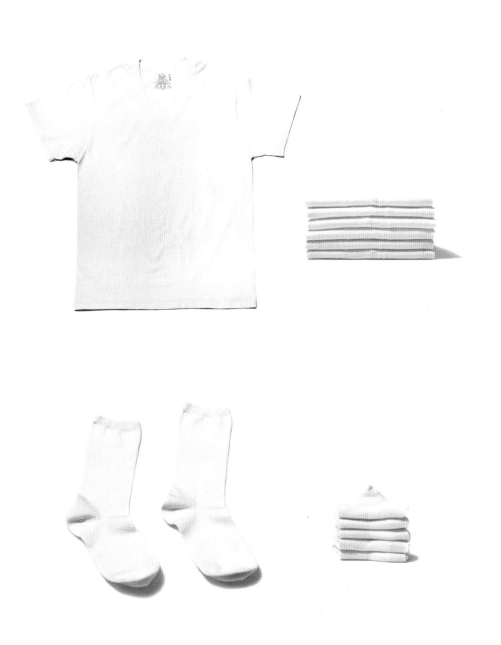

(And her socks.)

One Robe and two nightgowns.
For watching JEOPARDY!
and drinking tea from a glass.

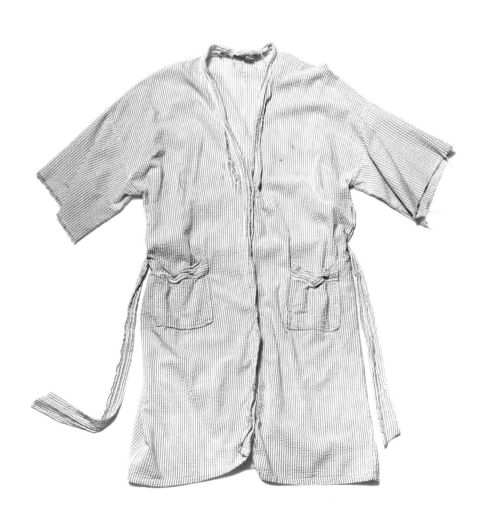

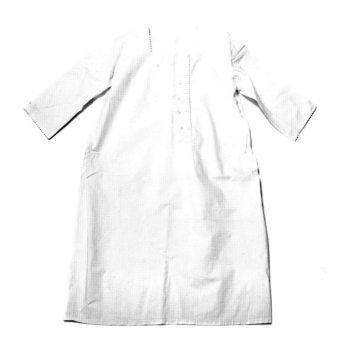

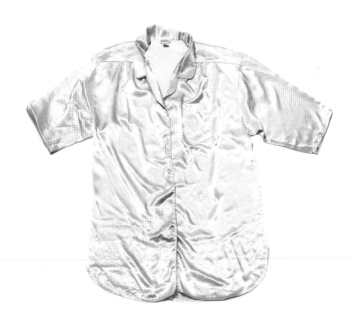

Thirteen blouses.

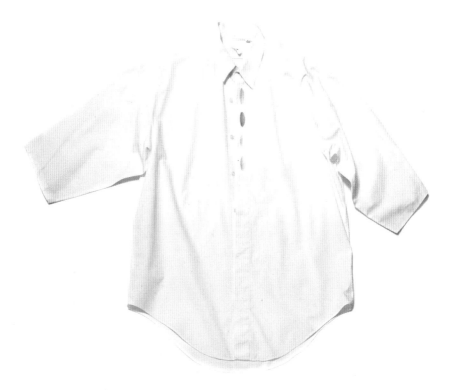

Mostly purchased from Loehmann's
and Lord & Taylor. At Lord & Taylor,
she loved going to the BIRD CAge
Restaurant with her daughters to eat
a plate of tea sandwiches.

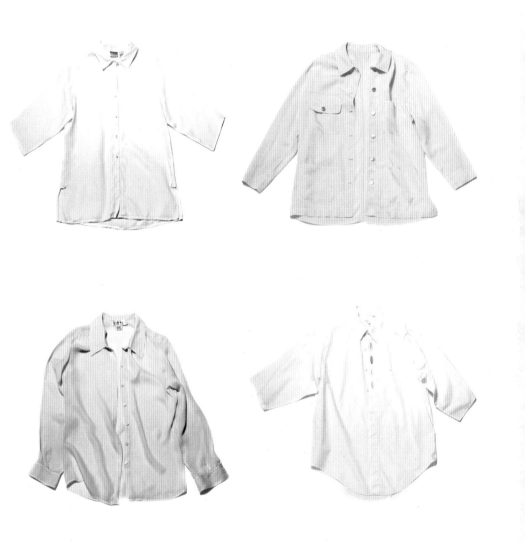

Pants.
The number is UNCERtain.

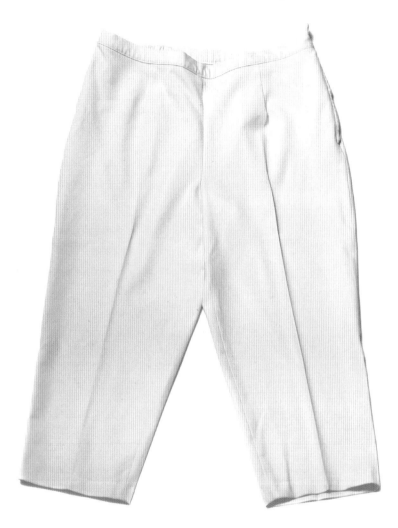

But all were pressed with a
sharp CREase.

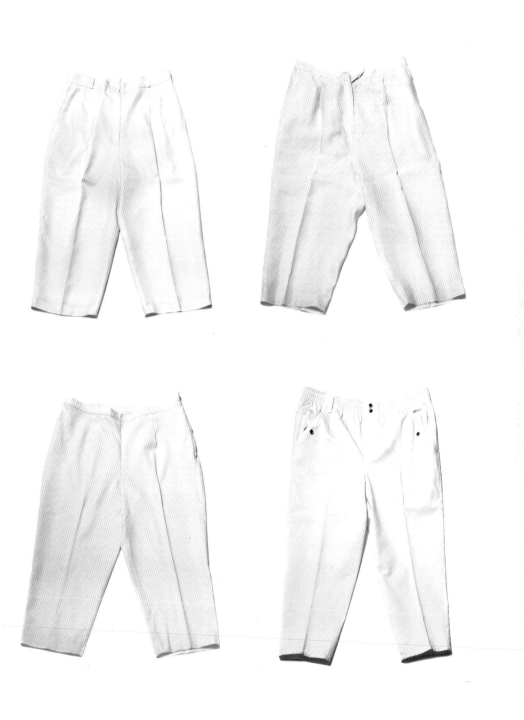

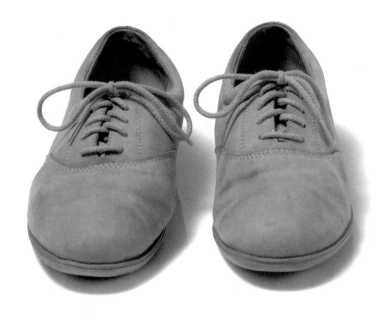

NiNe Pairs of ShoES.
She favored Easy Spirit.

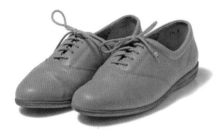

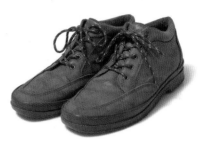

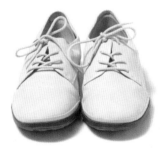

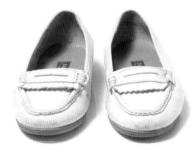

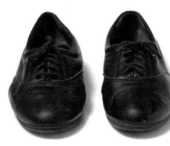

Six Fluffy Sweaters.

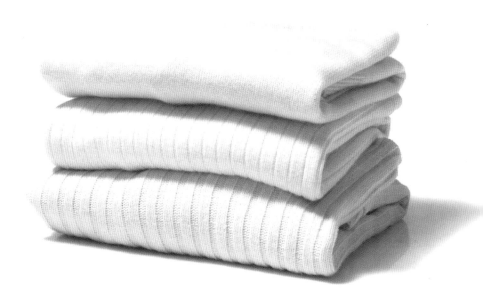

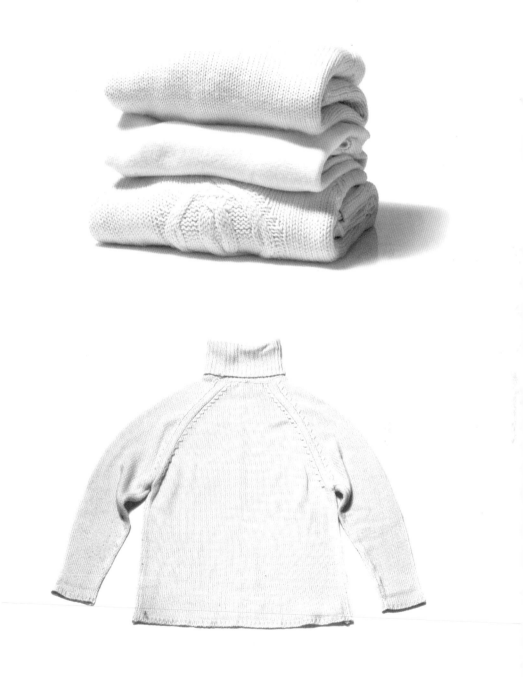

Seven White Hats.

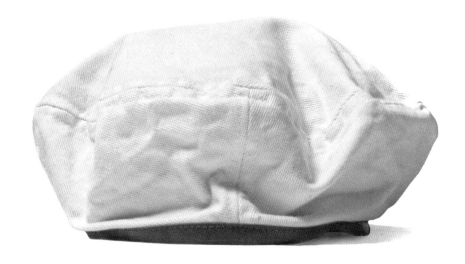

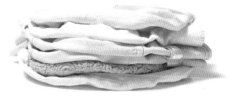

Many Linens.

Tablecloths and sheets and pillowcases.
All heavily starched and perfectly ironed.

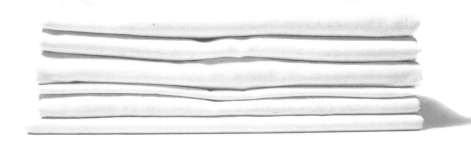

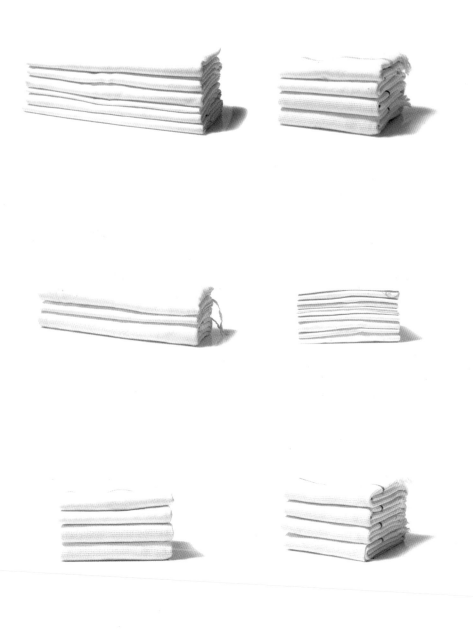

Beauty Products and accessories.

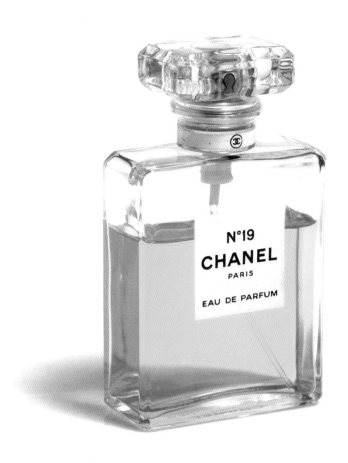

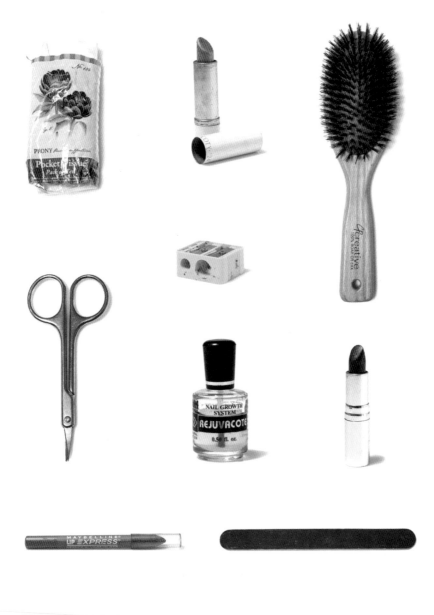

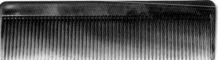

Pocketbooks and Luggage.
She used a set of Louis Vuitton suitcases.
Some Real. Some fake.

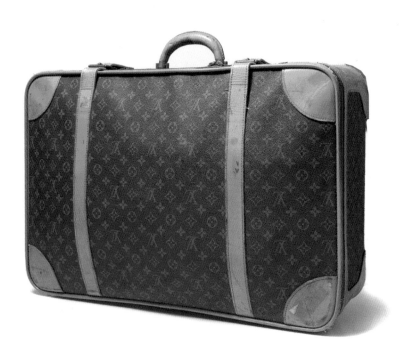

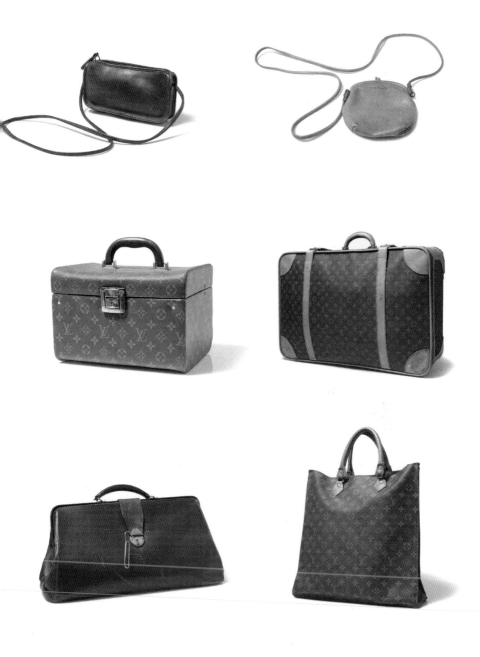

A variety of useful objects,
like a potato grater.

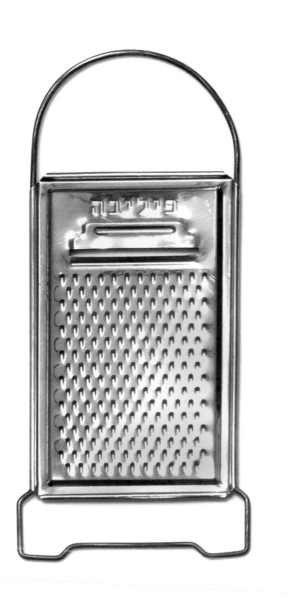

a paperweight,
and a cookie press
for making sesame cookies.

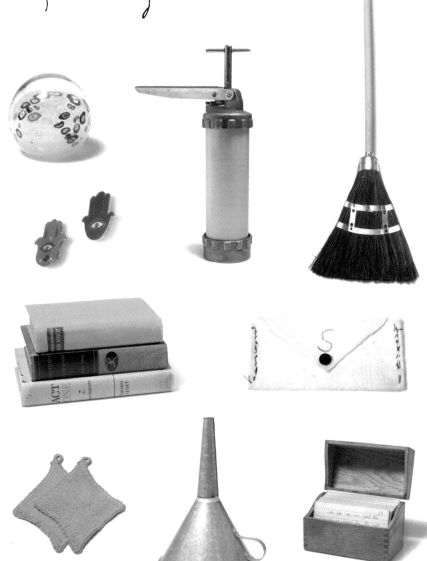

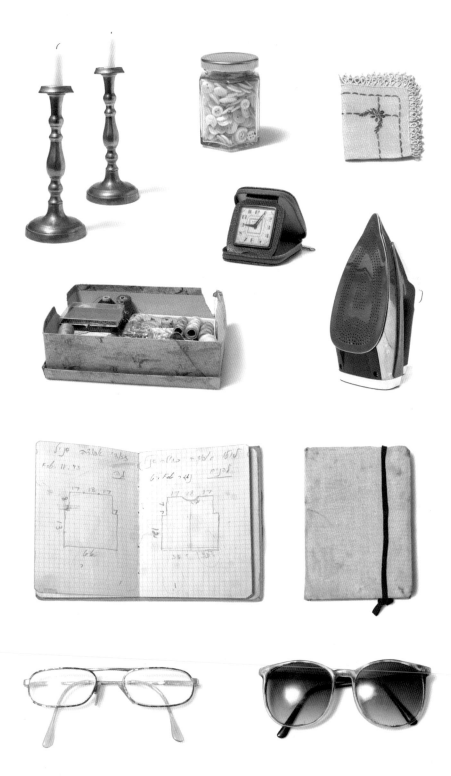

There were three M+Co watches that she wore at the same time. She used to wear two. But when her beloved son-in-law Tibor died, she took the one he had worn and added that to the group.

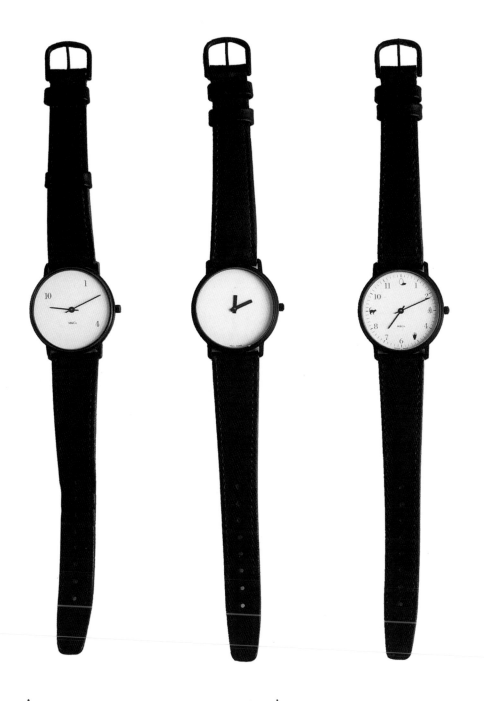

Los Angeles New York Tel Aviv

And there are letters.

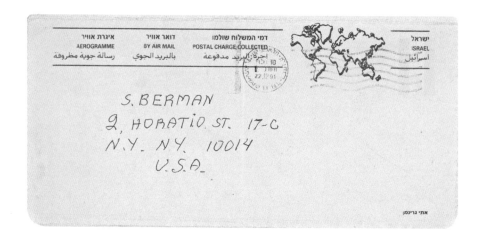

S. BERMAN
2, HORATIO. ST. 17-C
N.Y. N.Y. 10014
U.S.A.

She and her sister Shoshana
wrote letters to each other every
week, all the years they lived apart.

They wRote about the ups and downs
of family Life.

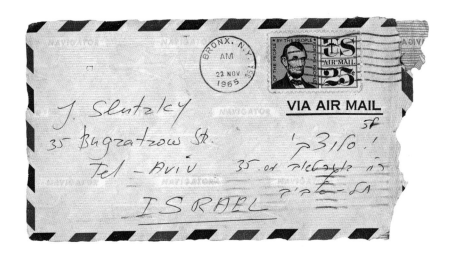

Both sisters wRote beautifully.

Shoshana wrote to Sara:
"Without the OCEAN, I could NOT SURVIVE."

Sara wrote to Shoshana:
"I have taught myself not to worry so much. In the end, all works out well and worrying is useless and self-destructive."

Sara did not spend all day working on her closet.

She did many other things.

But the closet was an expression of something that went back to her life in the village of Lenin. A way to create order out of chaos. A way to create a life of beauty and meaning.

And that is no small achievement.

ניו-יורק, 9 לחודש ... 1963

אמא יקירתי,

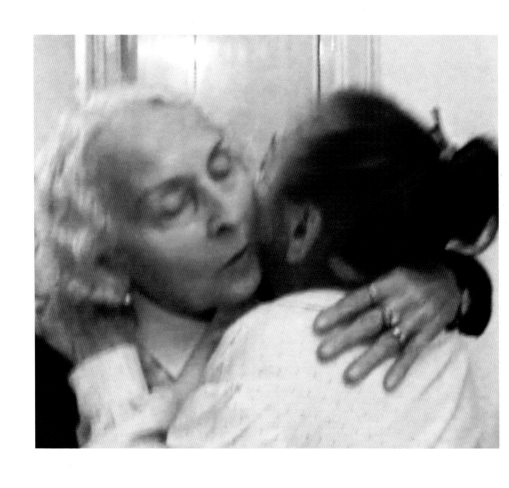

There were trips to Israel to visit the family.

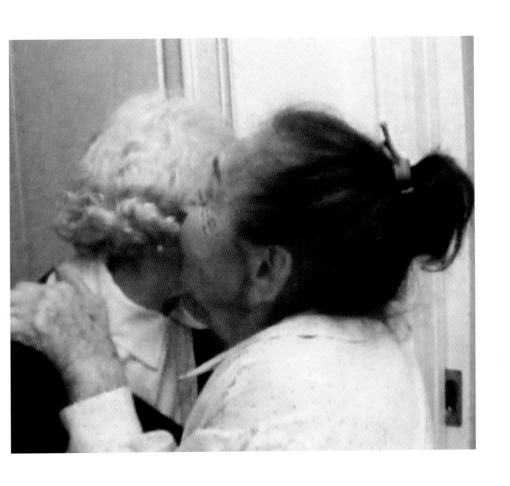

The sisters embraced.

Sara ate a Lemon Ice on the beach and held it up to the sun.

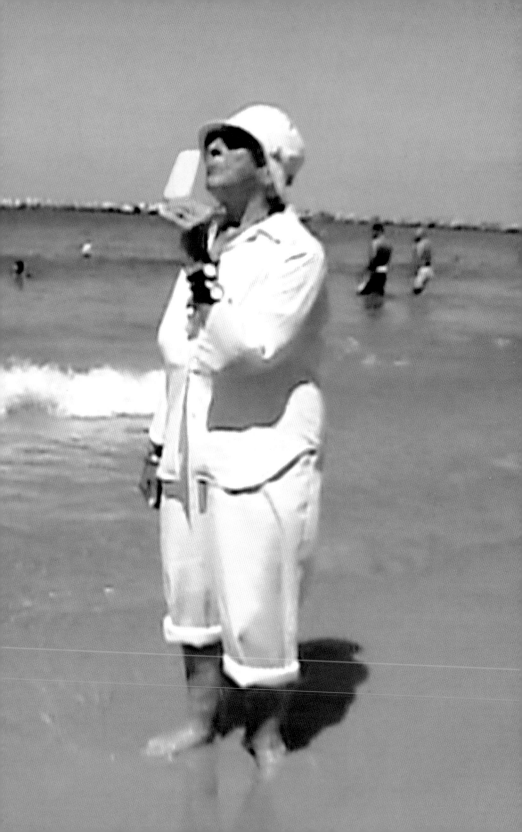

The family gathered one night
to celebrate the High Holidays.
Sara and Shoshana spent the evening
together, singing.

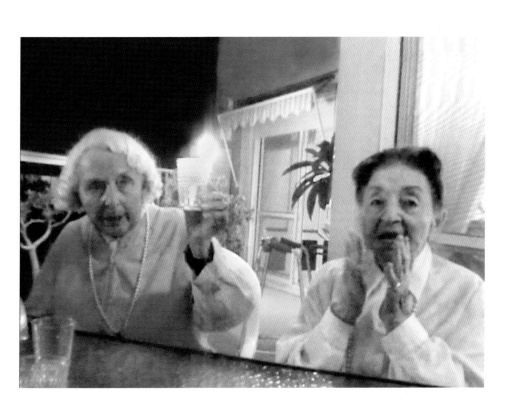

It was an enchanted Night.

The next morning,
Sara did not come
down to breakfast.

Her end had come
in a whisper.

When Sara's family returned
to New York from Tel Aviv,
it was clear to them that
her closet was a WORK of aRt
that needed to be preserved.

They stored all her belongings,
with the certainty that one day
her closet would be an exhibition.

Ten years later,
in a little museum
called MMUSEUMM,
in an alley in lower Manhattan,
SARA BERMAN'S CLOSET
opened to the public.

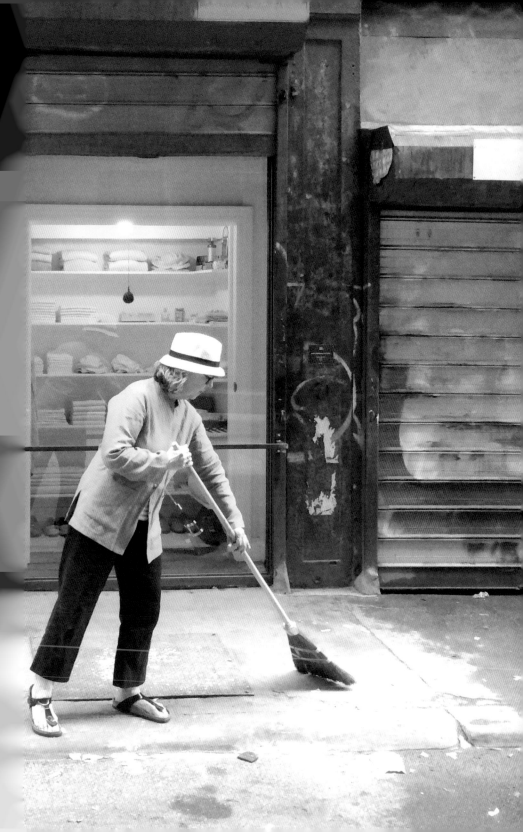

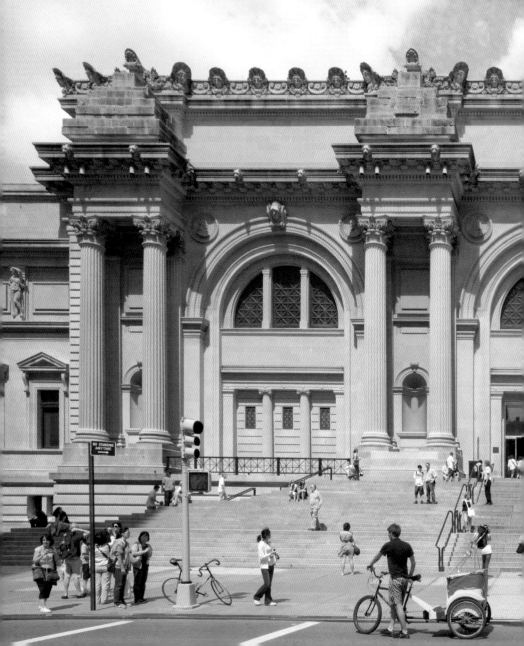

When the exhibit
left MMUSEUMM,

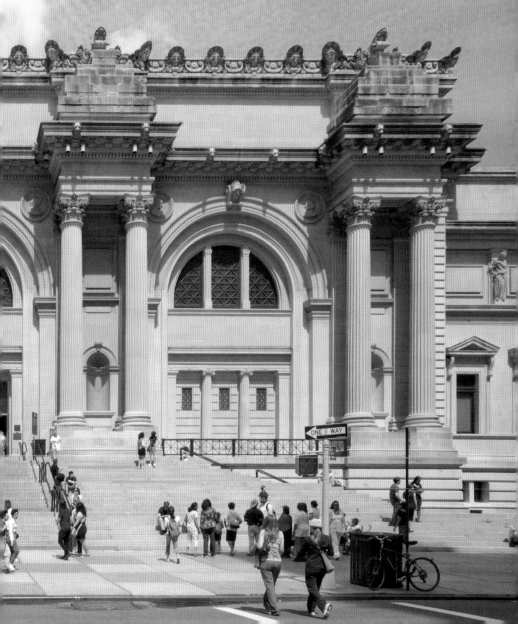

it moved to the
METROPOLITAN Museum
of Art.

Guards were now
watching over
Sara's bras.

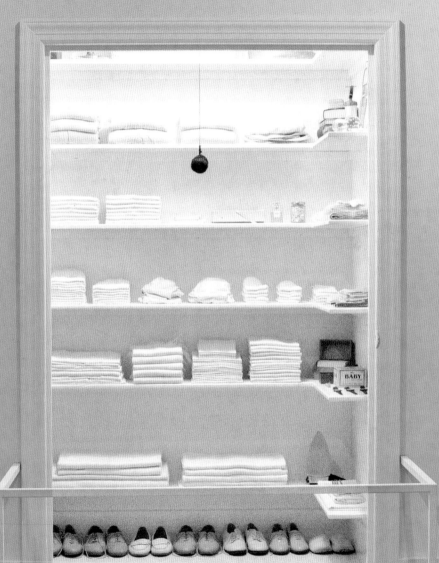

Inspired by Sara's simplicity, and clarity, people traveled from around the world to see the closet.

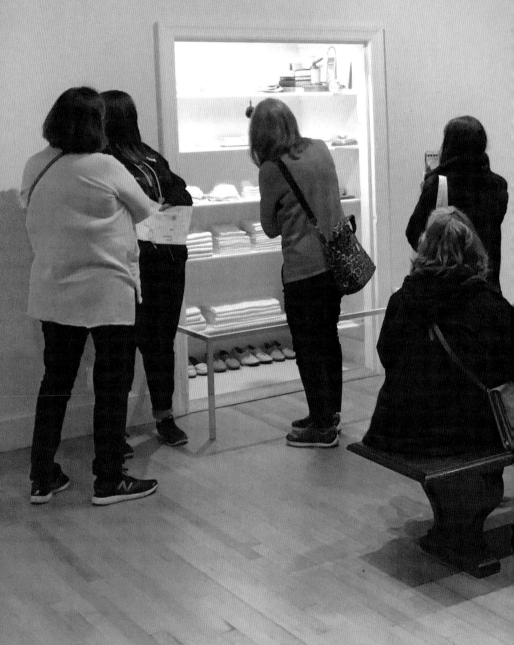

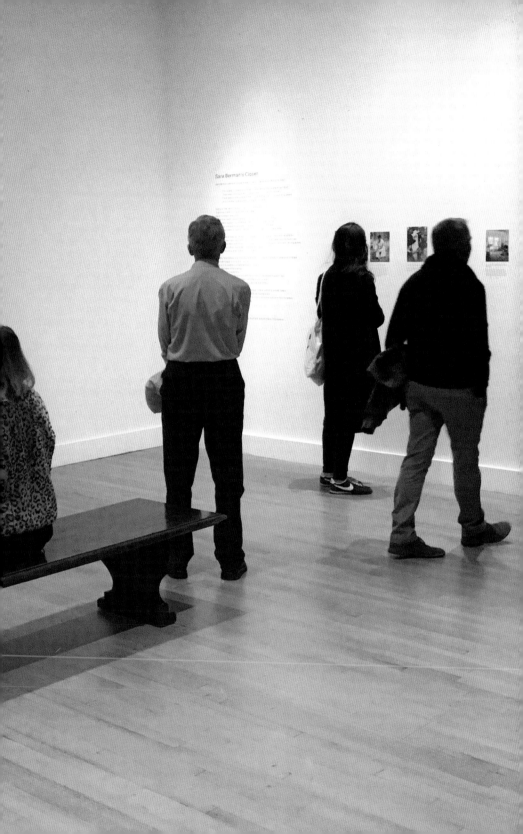

Today, Sara's closet makes its way
around the world,
telling a small and
monumental story.

How a life is formed.

How meaning is found.

How mistakes are made.

And how we have the
courage to go on.

If we could ask Sara
what she thinks about the
whole thing,

She might simply say,

"TGIF."

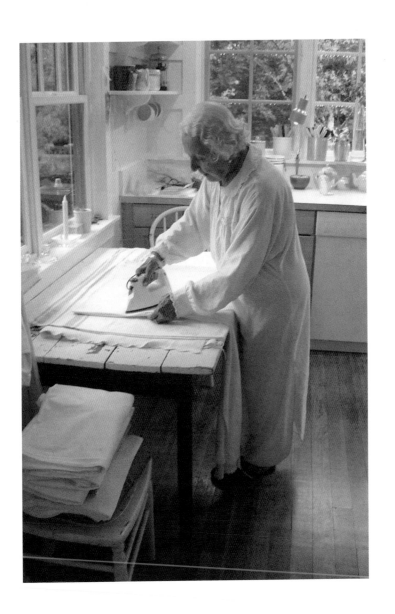

Sara's Star Sesame Cookies

Sara distributed her cookies in tins to friends around the city. If you were lucky enough to get one, you became addicted.

Ingredients

(makes 8-10 dozen cookies)

2 1/2 cups all purpose flour
1 tablespoon baking powder
1/2 cup sugar
2 JUMBO eggs
1 3/4 sticks unsalted butter
1 1/2 cups sesame seeds
1 teaspoon SALT

Note: Eggs and butter should be at room temperature.

* * *

Preheat the oven to 350° F.

In a large bowl combine all ingredients by hand into a dough. We suggest removing any rings before mixing, unless you don't mind getting them doughy.

Place the dough into a cookie plunger with a star attachment. (Sara used the SAWA 2000 Deluxe.)

Press the dough onto a greased cookie sheet.

Bake for 20-30 minutes, or until the cookies are golden brown.

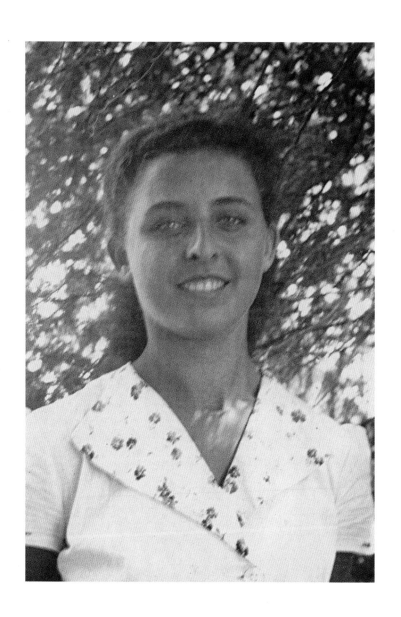

Everyone leaves somewhere.
Everyone leaves everyone.
And there you go.

thank you

Alexandra Eaton

Amelia Peck

Charlotte Sheedy

Chris Noey

Christine Coulson

Daniele Frazier

Elizabeth Sullivan

Jacob Ford

Jen Snow

Julie Saul

Kika Schoenfeld

Lila Elias

Lulu Kalman

Lynne Yeamans

Olive Orbit Bennett

Pesach Berman

Peter Wagner

Rick Meyerowitz

Russ & Daughters

Sarah Wilson

Slutsky Family

Sylvia Yount

Will Luckman

Yochevet Aronson

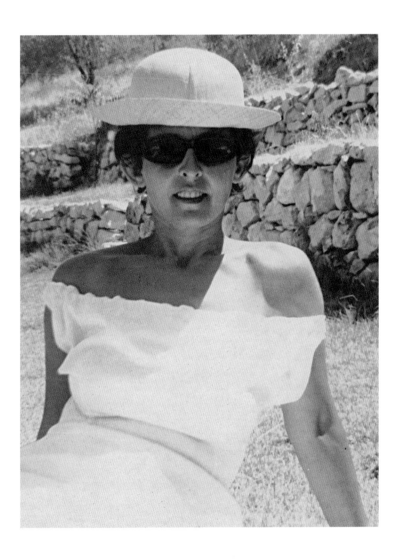

Photography and Illustration Credits

All of the paintings in this book are by Maira Kalman and all of the photographs are by Maira Kalman and Alex Kalman, except for the following:

22: Photographer unknown; commons.wikimedia.org/wiki/File:SS_PoloniaTrans.jpg.

29, clockwise from top left: Photographer unknown, commons.wikimedia.org /wiki/File:Portrait_Gandhi.jpg; photographer unknown, commons.wikimedia.org /wiki /File:Franz_Kafka_1917.jpg; Carl Van Vechten, commons.wikimedia.org /wiki/File:Gertrude_stein.jpg; Bain Collection, Library of Congress, commons. wikimedia .org/wiki/File:Toscanini 8.jpg.

56–89, 112–113, 126, end papers: Katherine Finkelstein, courtesy of Alex Kalman.

62: Naho Kubota.

107: Rick Meyerowitz.

110: © The Metropolitan Museum of Art, New York

Sara Berman's Closet

HarperCollins books may be purchased for educational, business, or sales
promotional use. For information please e-mail the Special Markets Department
at SPsales@harpercollins.com.

First published in 2018 by
Harper Design
An Imprint of HarperCollins*Publishers*
195 Broadway
New York, NY 10007
Tel: (212) 207-7000
Fax: (855) 746-6023
harperdesign@harpercollins.com
www.hc.com

Distributed throughout the world by
HarperCollins*Publishers*
195 Broadway
New York, NY 10007

ISBN 978-0-06-284640-2

Library of Congress Cataloging-in-Publication Data

Names: Kalman, Maira, author. | Kalman, Alex, author.
Title: Sara Berman's closet / Maira Kalman, Alex Kalman.
Description: New York : HarperCollins Publishers, [2018]
Identifiers: LCCN 2018016424 | ISBN 9780062846402 (hardcover)
Subjects: LCSH: Berman, Sara--Juvenile fiction. | Mothers--Juvenile fiction.
Classification: LCC PZ7.K1256 Sar 2018 | DDC [E]--dc23 LC record
available at https://lccn.loc.gov/2018016424

Book design by Alex Kalman & What Studio?
Printed in China

First Printing, 2018

MAIRA KALMAN is an author and illustrator of more than twenty-eight books for adults and children. A contributor to the *New York Times* and *The New Yorker*, she is the co-creator with John Heginbotham of a ballet based on her book *The Principles of Uncertainty*. Represented by the Julie Saul Gallery, she has exhibited her work at museums worldwide. She owns a pair of Toscanini's pants and lives in New York City. www.mairakalman.com

ALEX KALMAN is a designer, creative director, curator, and inventor. He is the owner of What Studio? and the founder of Mmuseumm. A contributor to the *New York Times*, his work has been exhibited at museums worldwide. He lives in New York City. www.whatstudio.xyz

Sara Berman's Closet was first exhibited at Mmuseumm 2, New York City, in 2015.

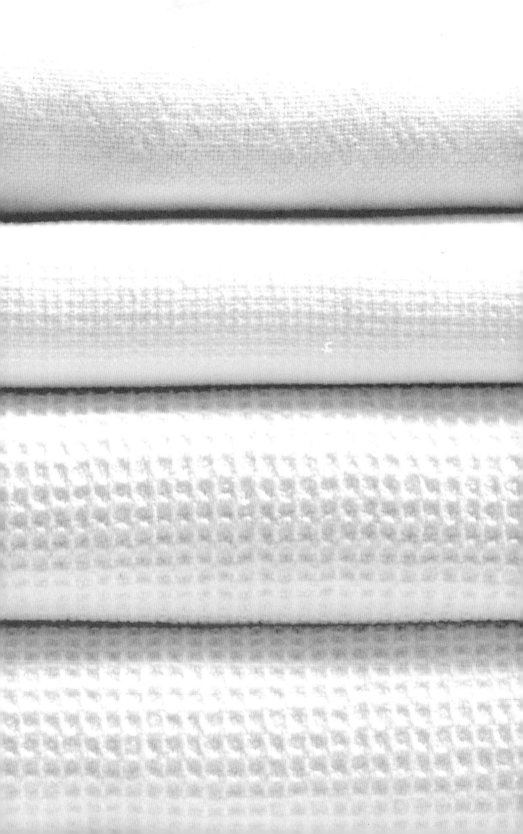